Love You
GRANDMA
doodle & dream

Love You Grandma: doodle & dream

First published in the United Kingdom in 2015 by
Bell & Mackenzie Publishing Limited

ISBN 978-1-909855-84-7

A CIP catalogue record of this book is available from the British Library

Created by Christina Rose

Credits: mattasbestos/shutterstock, Katerina Kirilova/shutterstock, Falkovsky/shutterstock, Morozova Olga/shutterstock, facai/shutterstock, A-R-T/shutterstock, Rouz/shutterstockReal Illusion/shutterstock, Miroslava Hlavacova/shutterstock, andamanec/shutterstock, AllaR15/shutterstock, Alexandra Dzh/shutterstock, MaryMo/shutterstock, cupoftea/shutterstock, Julia Snegireva/shutterstock, VOOK/shutterstock, Anton Tonitoon/shutterstock, Liukas/shutterstock, karakotsya/shutterstock, Marina99/shutterstock, Kateika/shutterstock, Sayanny/shutterstock, Axro/shutterstock, Dovile Kuusiene/shutterstock, Olga Korneeva/shutterstock, LanaN/shutterstock, alex.makarova/shutterstock, Silvia Popa/shutterstock, rvika/shutterstock, UyUy/shutterstock, Mire/shutterstock, Fears/shutterstock, Tatiananna/shutterstock, Adrian Niederhaeuser/shutterstock, Emila/shutterstock, balabolka/shutterstock, Naticka/shutterstock, Macrovector/shutterstock, Claudiu Mihai Badea/shutterstock

www.bellmackenzie.com

This book is given to

..

in love and appreciation of

everything you have done.

A child needs a grandparent, anybody's grandparent, to grow a little more securely into an unfamiliar world.

Charles and Ann Morse

A garden of love grows in a grandmother's heart.

Author Unknown

A grandmother is a safe haven.

Suzette Haden Elgin

A grandmother is a little bit parent, a little bit teacher, and a little bit best friend.

Author Unknown

A grandmother is a mother who has a second chance.

Author Unknown

A grandmother pretends she doesn't know who you are on Halloween.

Erma Bombeck

A house needs a grandma in it.

Louisa May Alcott

A married daughter with children puts you in danger of being catalogued as a first edition.

Author Unknown

A mother becomes a true grandmother the day she stops noticing the terrible things her children do because she is so enchanted with the wonderful things her grandchildren do.

Lois Wyse

Beautiful young people are accidents of nature, but beautiful old people are works of art.

Eleanor Roosevelt

Being grandparents sufficiently removes us from the responsibilities so that we can be friends.

Allan Frome

Few things are more delightful than grandchildren fighting over your lap.

Doug Larson

Grandchildren are the dots that connect the lines from generation to generation.

Lois Wyse

Grandchildren are God's way of compensating us for growing old.

Mary H. Waldrip

Grandma always made you feel she had been waiting to see just you all day and now the day was complete.

Marcy DeMaree

Grandmas are moms with lots of frosting.

Author Unknown

Grandmas hold our tiny hands for just a little while, but our hearts forever.

Author Unknown

Grandmas never run out of hugs or cookies.

Author Unknown

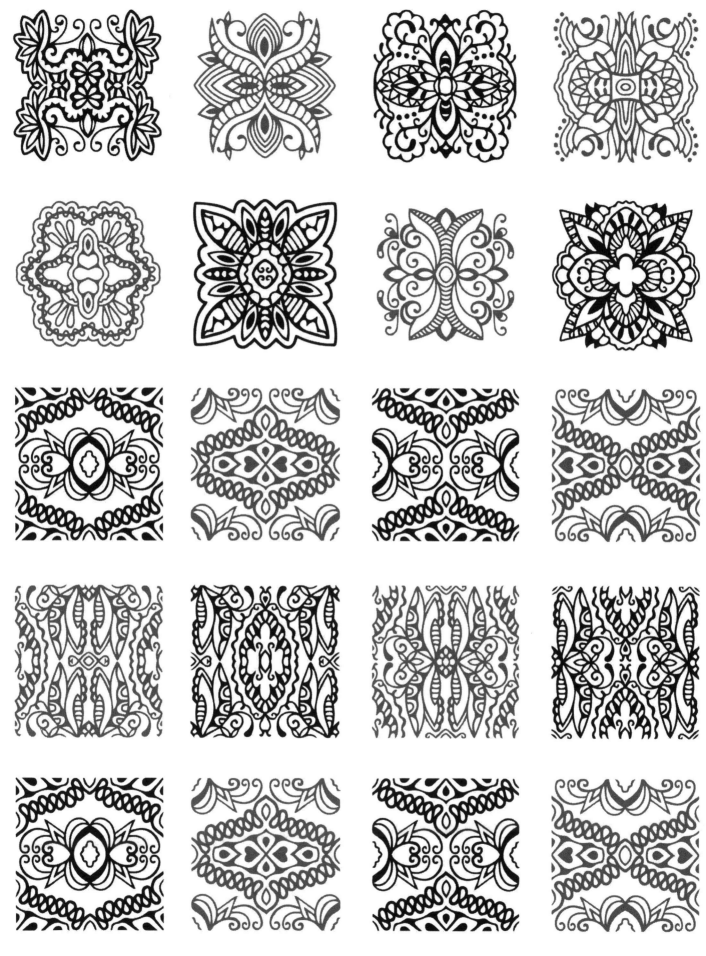

Grandmother - a wonderful mother with lots of practice.

Author Unknown

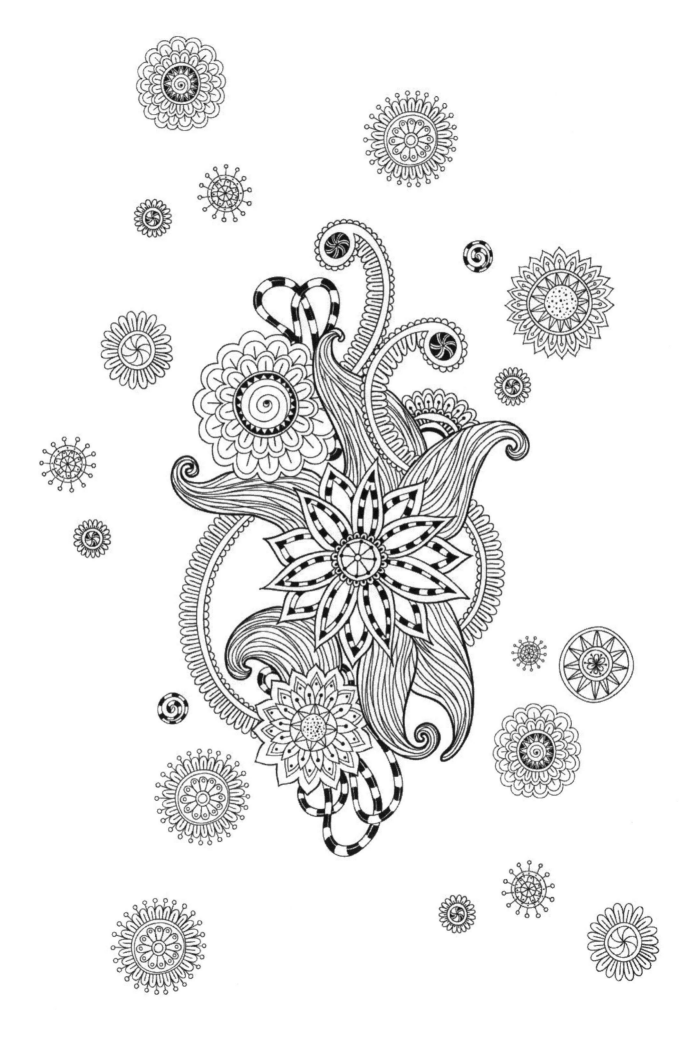

Grandmothers are just antique little girls.

Author Unknown

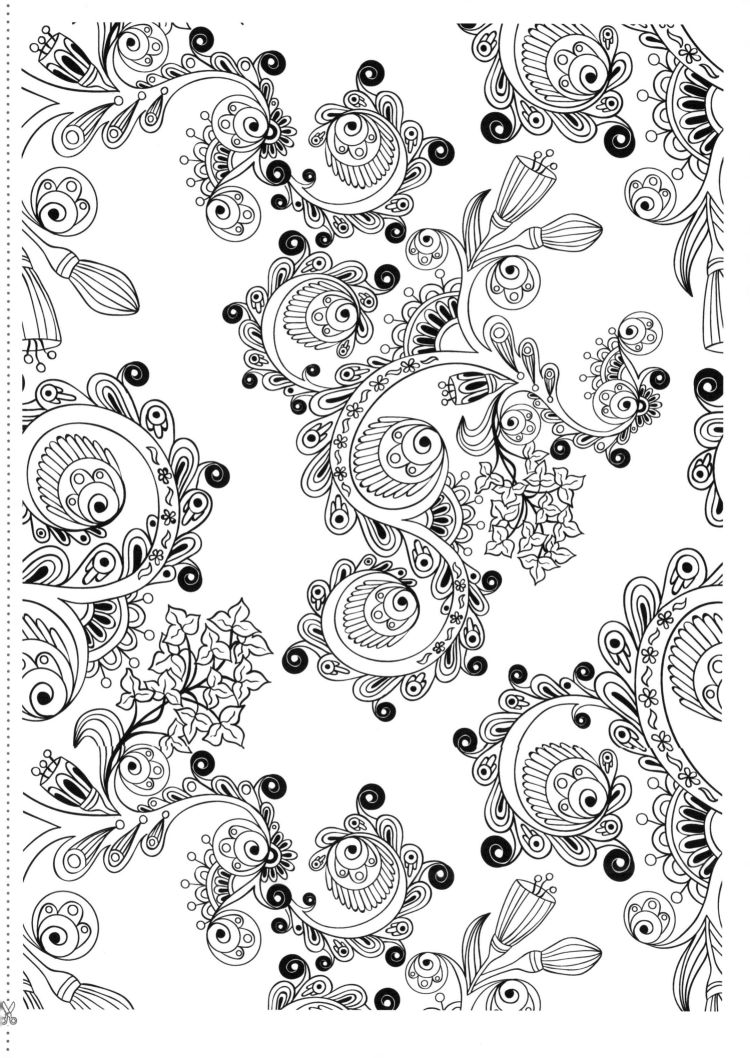

Grandparents are similar to a piece of string—handy to have around and easily wrapped around the fingers of their grandchildren.

Author Unknown

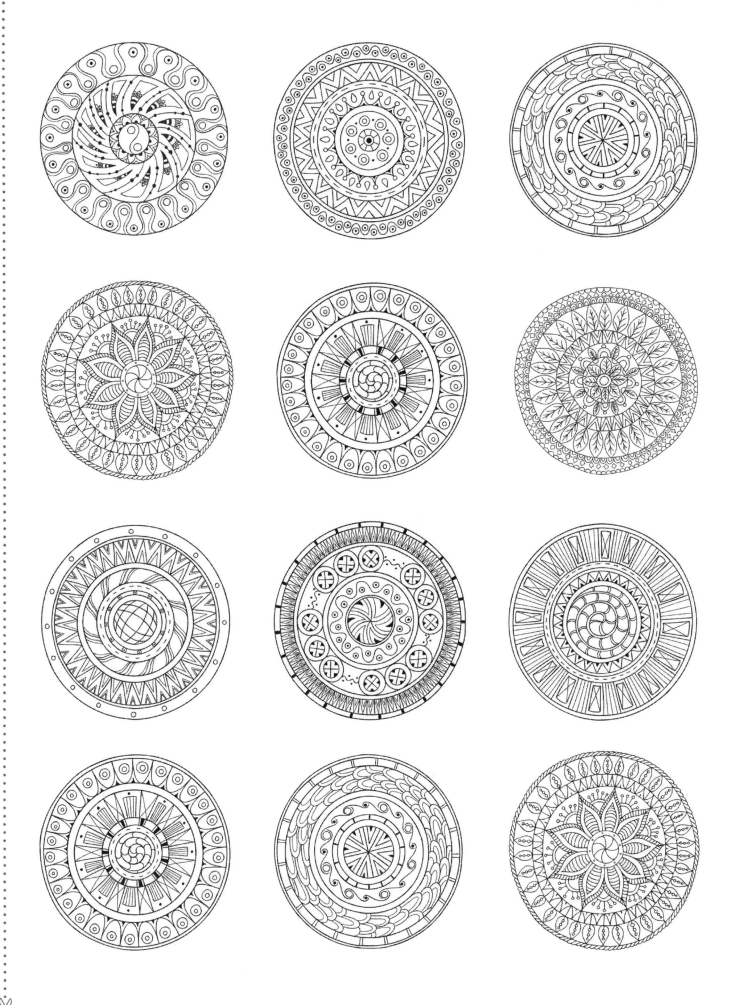

Grandparents are there to help the child get into mischief they haven't thought of yet.

Gene Perret

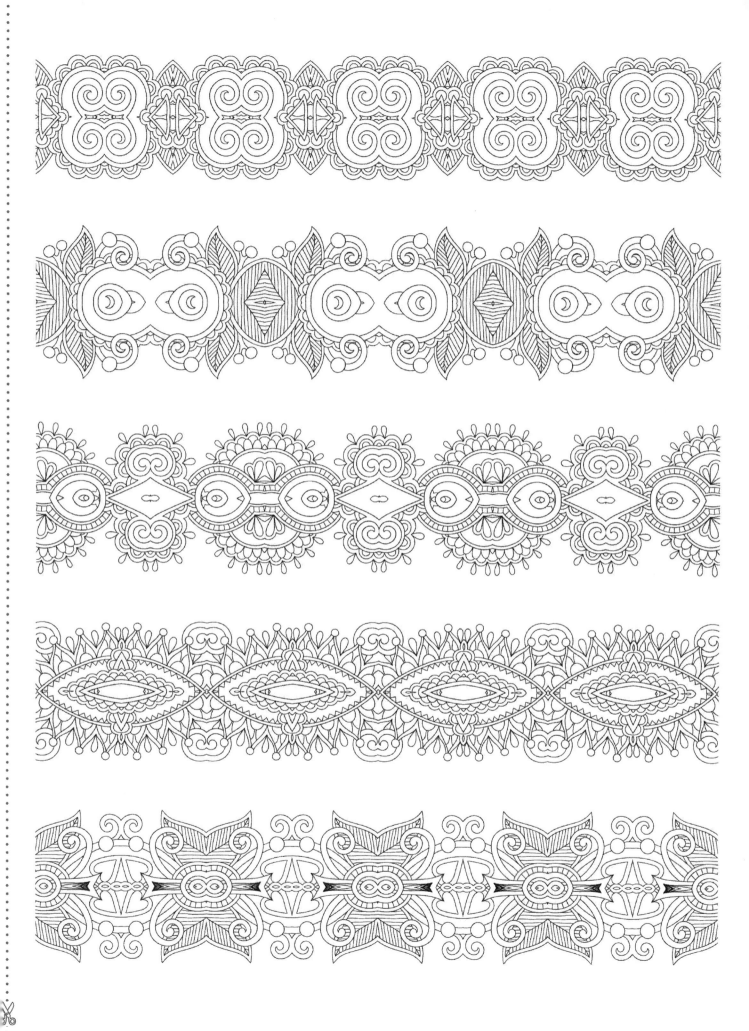

Holding these babies in my arms makes me realize the miracle my husband and I began.

Betty Ford

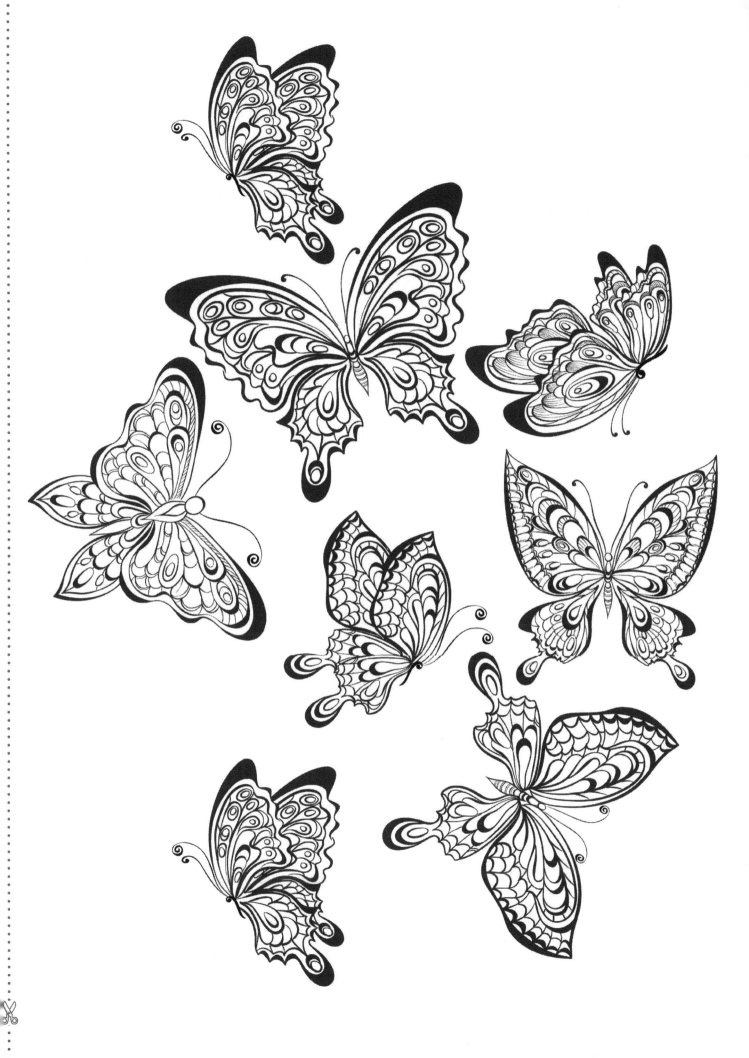

If becoming a grandmother was only a matter of choice, I should advise every one of you straight away to become one. There is no fun for old people like it!

Hannah Whithall Smith

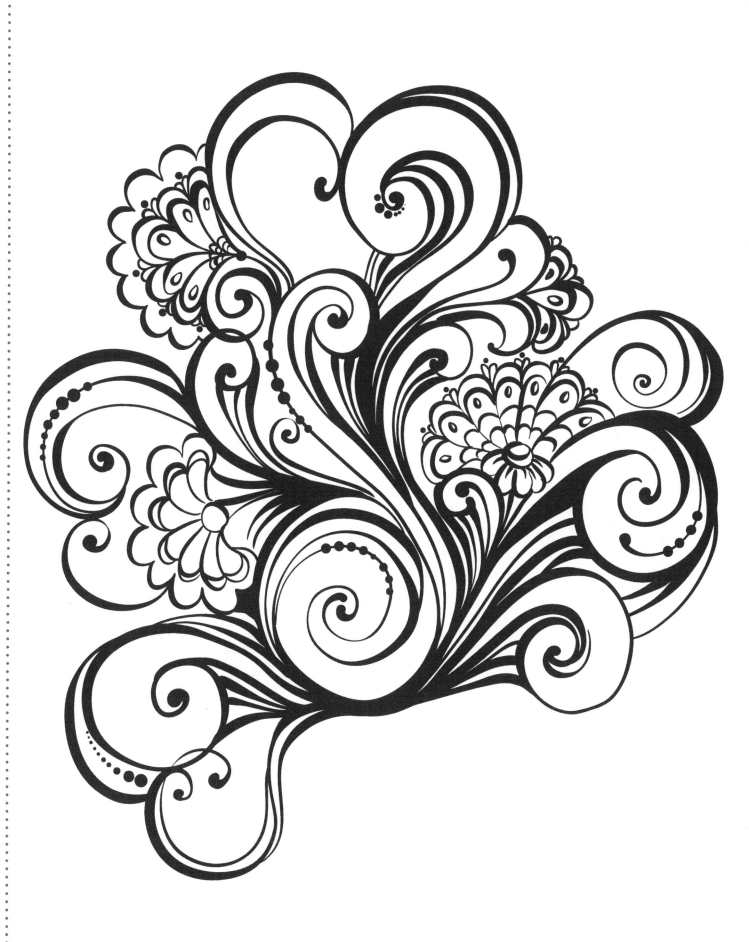

If God had intended us to follow recipes, He wouldn't have given us grandmothers.

Linda Henley

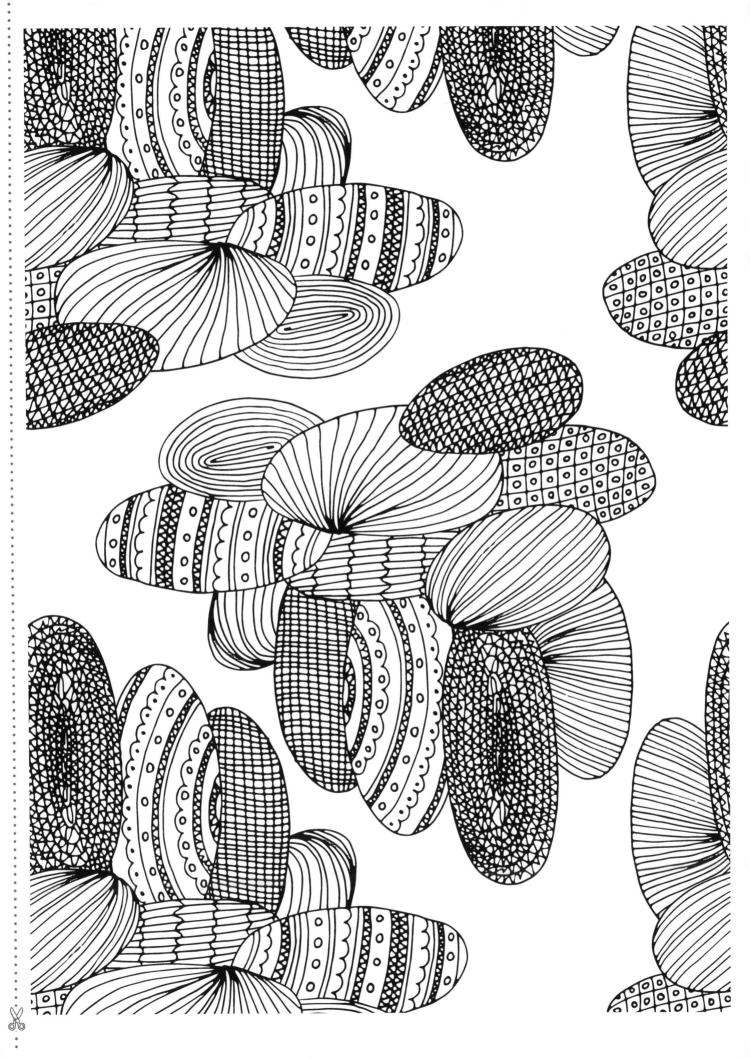

If I had known how wonderful it would be to have grandchildren, I'd have had them first.

Lois Wyse

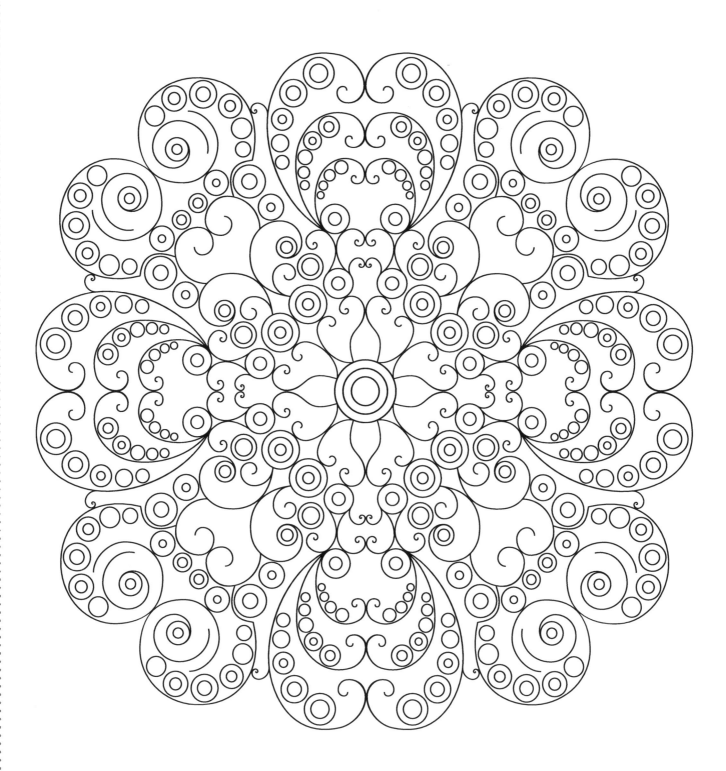

If your baby is "beautiful and perfect, never cries or fusses, sleeps on schedule and burps on demand, an angel all the time," you're the grandma.

Teresa Bloomingdale

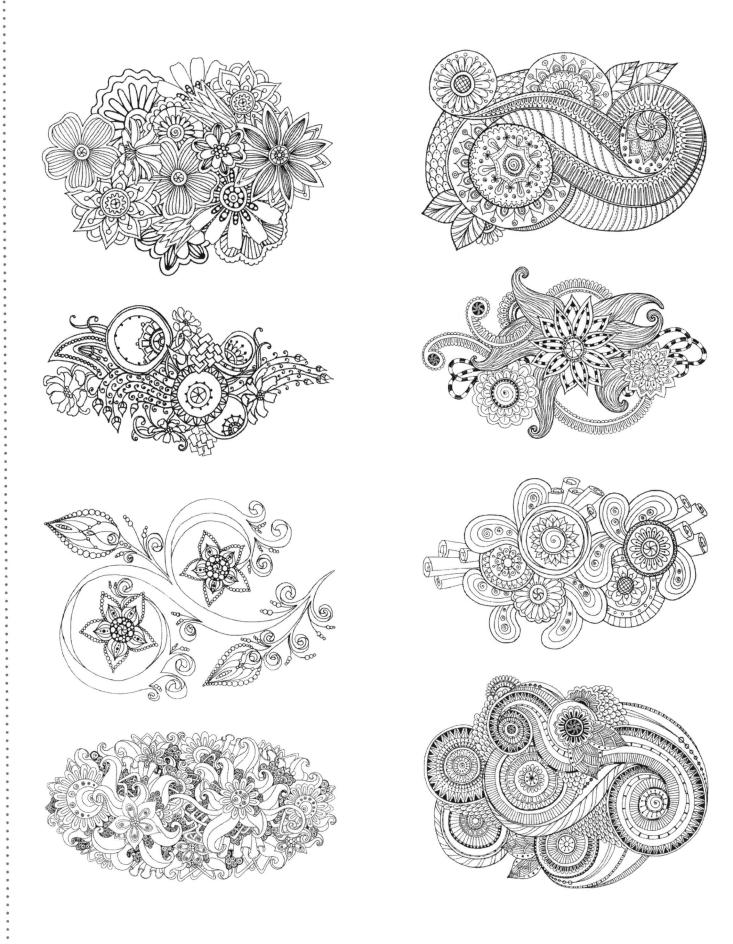

It is as grandmothers that our mothers come into the fullness of their grace.

Christopher Morley

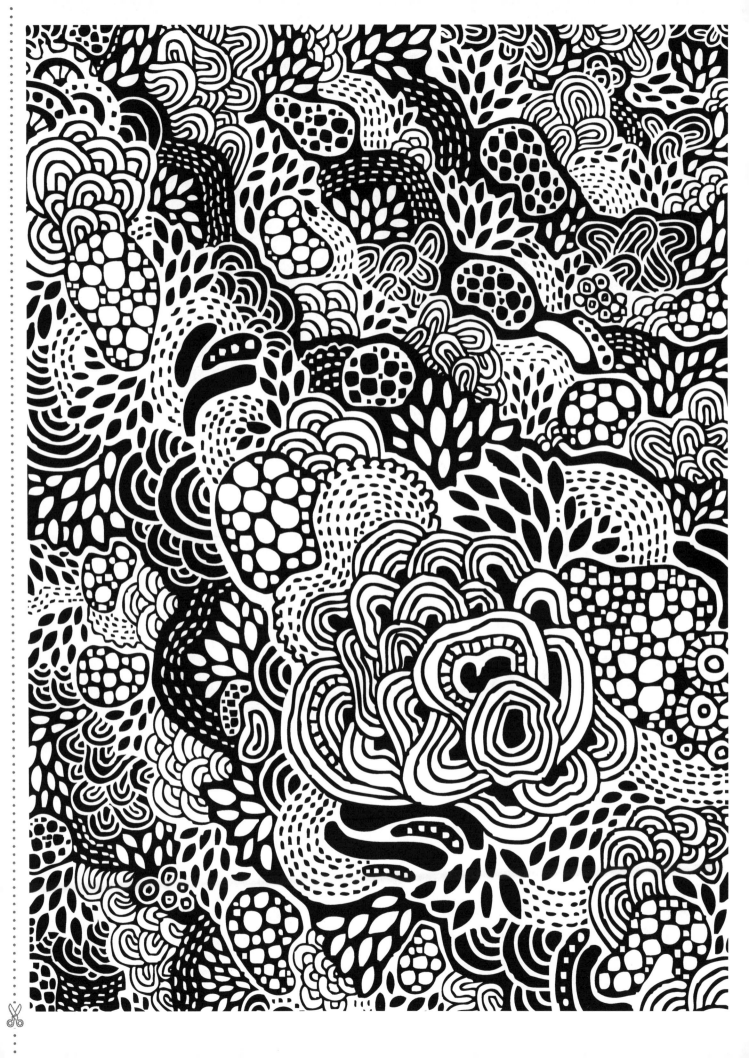

It is one of nature's ways that we often feel closer to distant generations than to the generation immediately preceding us.

Igor Stravinsky

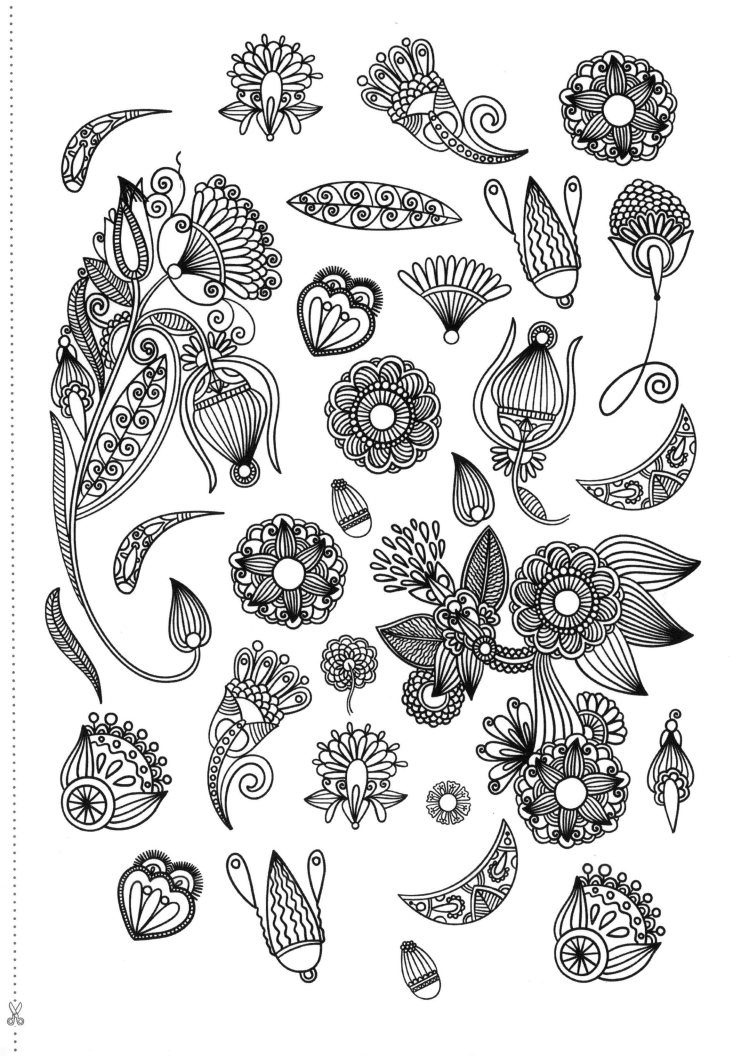

It's such a grand thing to be a mother of a mother — that's why the world calls her grandmother.

Author Unknown

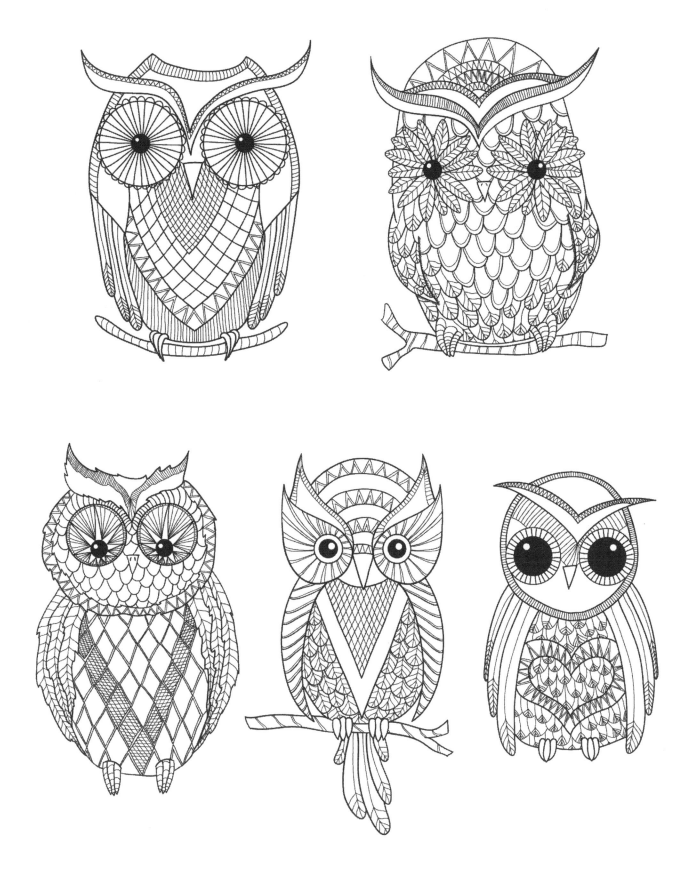

Just about the time a woman thinks her work is done, she becomes a grandmother.

Edward H. Dreschnack

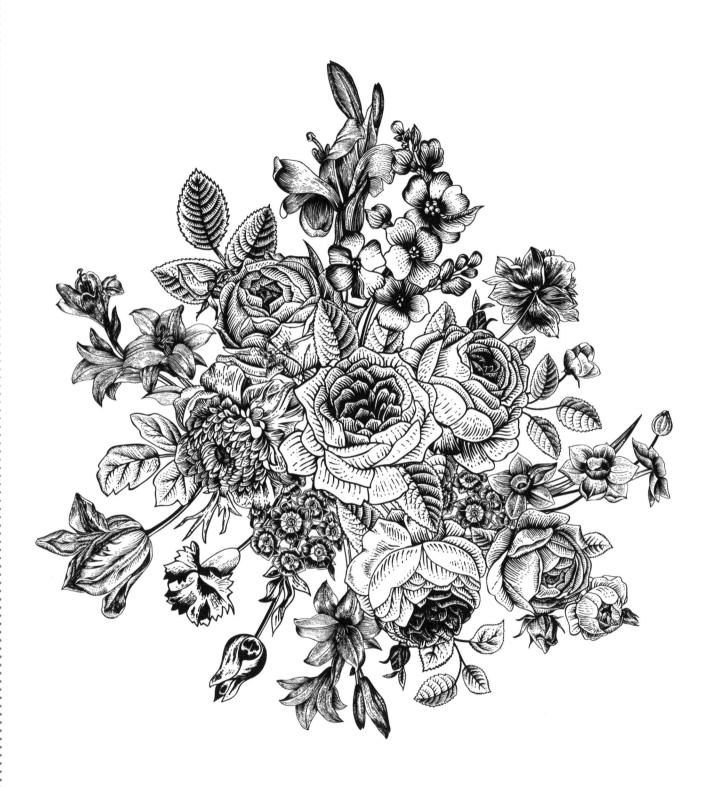

Most grandmas have a touch of the scallywag.

Helen Thomson

Never have children, only grandchildren.

Gore Vidal

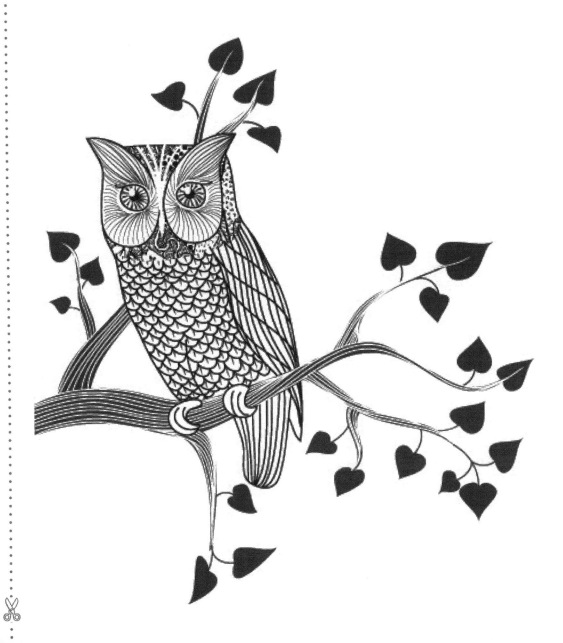

No matter how many grandchildren you may have, each one holds a special place in your heart and a delicate bond that can never be broken.

Alvaretta Roberts

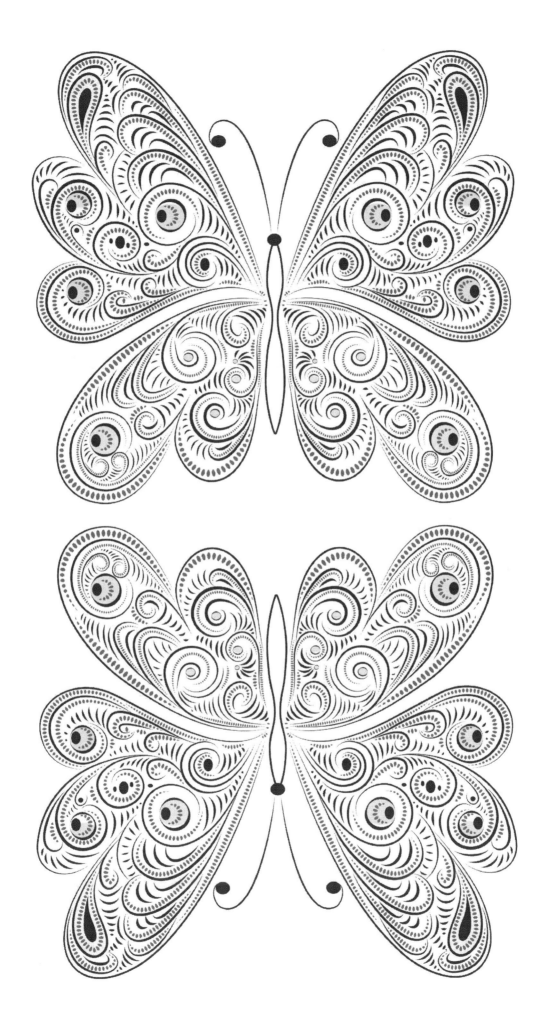

Our grandchildren accept us for ourselves, without rebuke or effort to change us, as no one in our entire lives has ever done, not our parents, siblings, spouses, friends — and hardly ever our own grown children.

Ruth Goode

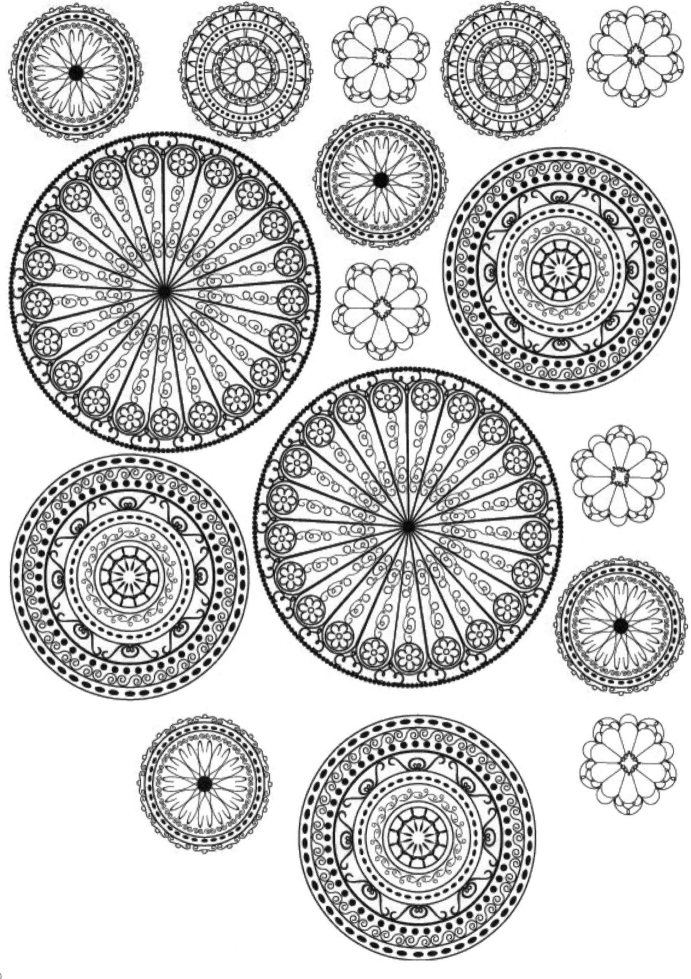

Perfect love sometimes does not come until the first grandchild.

Welsh Proverb

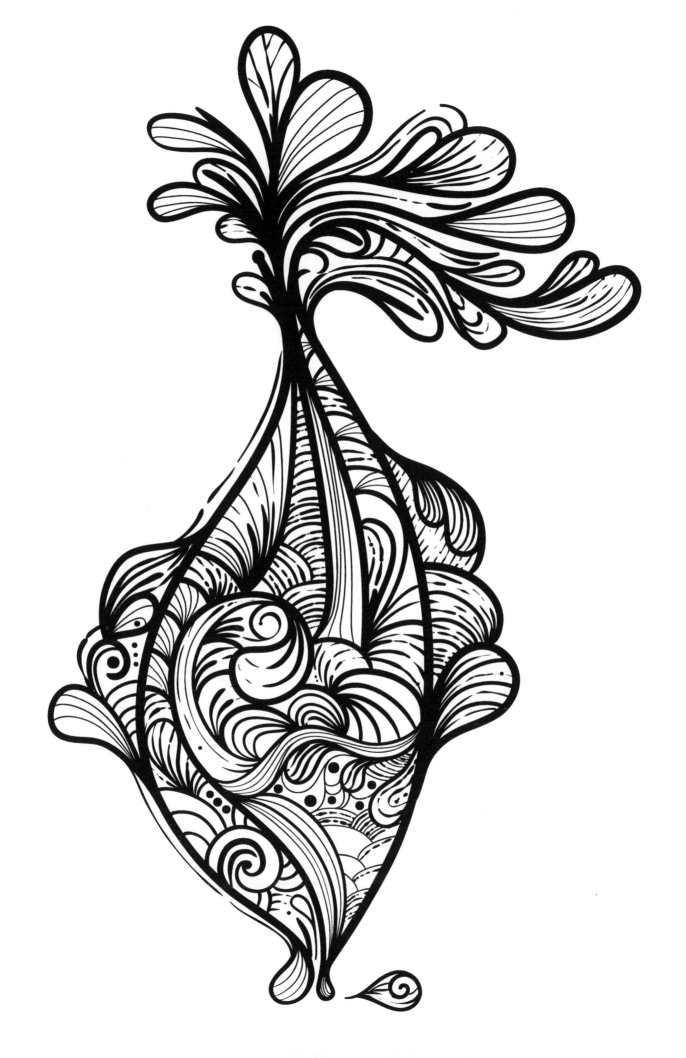

Sometimes our grandmas and grandpas are like grand-angels.

Lexie Saige

Surely, two of the most satisfying experiences in life must be those of being a grandchild or a grandparent.

Donald A. Norberg

There's no place like home... except Grandma's.

Author Unknown

The simplest toy, one which even the youngest child can operate, is called a grandparent.

Sam Levenson

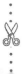

Truth be told, being a grandma is as close as we ever get to perfection. The ultimate warm sticky bun with plump raisins and nuts. Clouds nine, ten, and eleven.

Bryna Nelson Paston

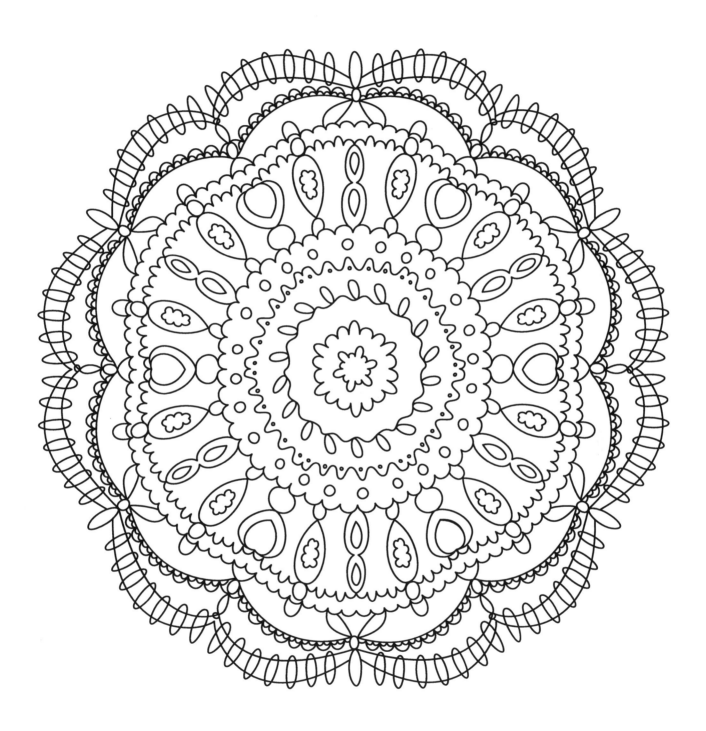

Uncles and aunts, and cousins, are all very well, and fathers and mothers are not to be despised; but a grandmother, at holiday time, is worth them all.

Fanny Fern

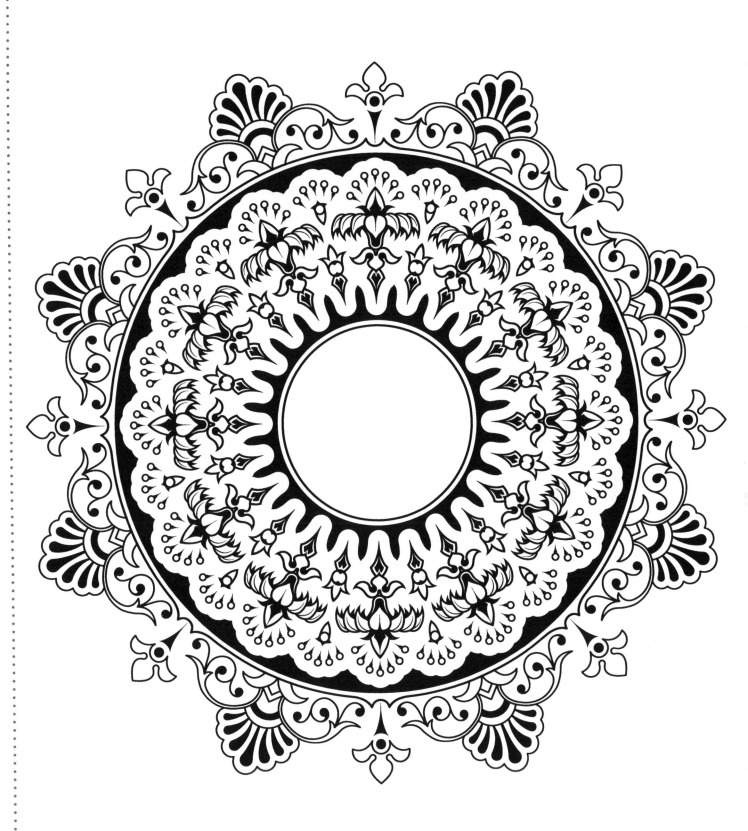

Becoming a grandmother is wonderful. One moment you're just a mother. The next you are all-wise and prehistoric.

Pam Brown

What children need most are the essentials that grandparents provide in abundance. They give unconditional love, kindness, patience, humor, comfort, lessons in life. And, most importantly, cookies.

Rudy Giuliani

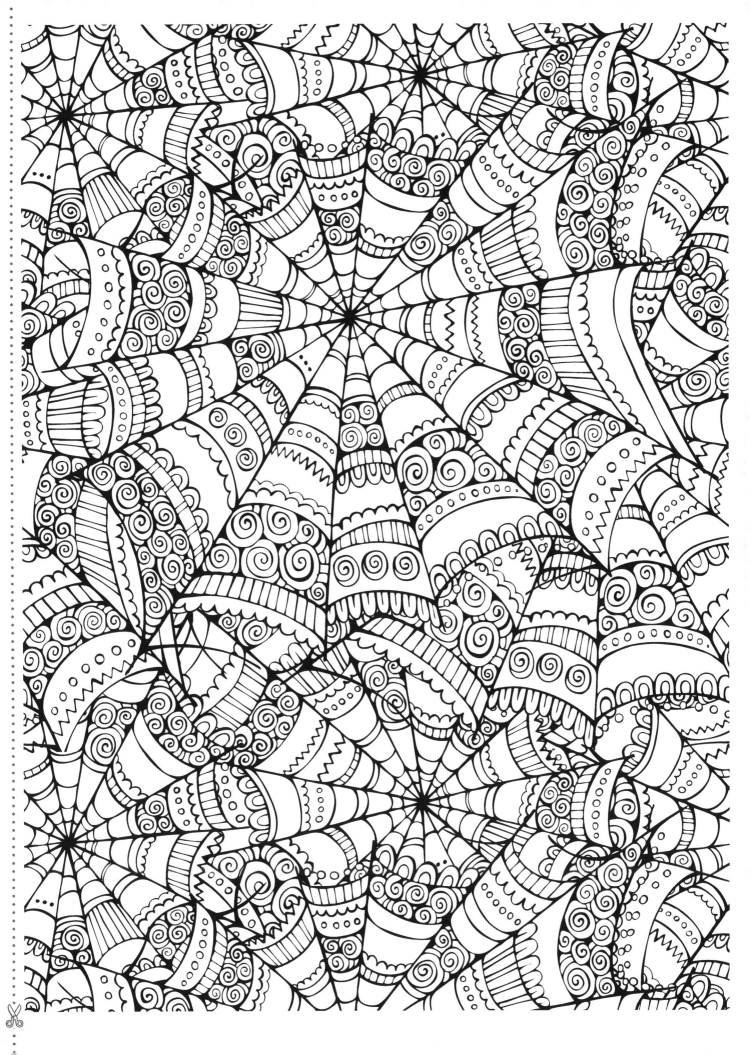

When grandparents enter the door, discipline flies out the window.

Ogden Nash

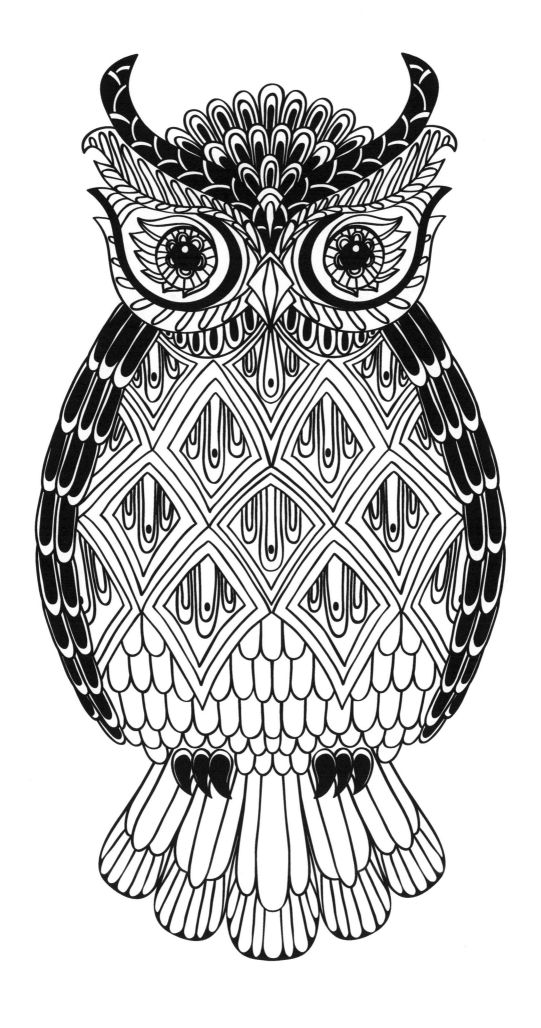

You are the sun, Grandma, you are the sun in my life.

Kitty Tsui

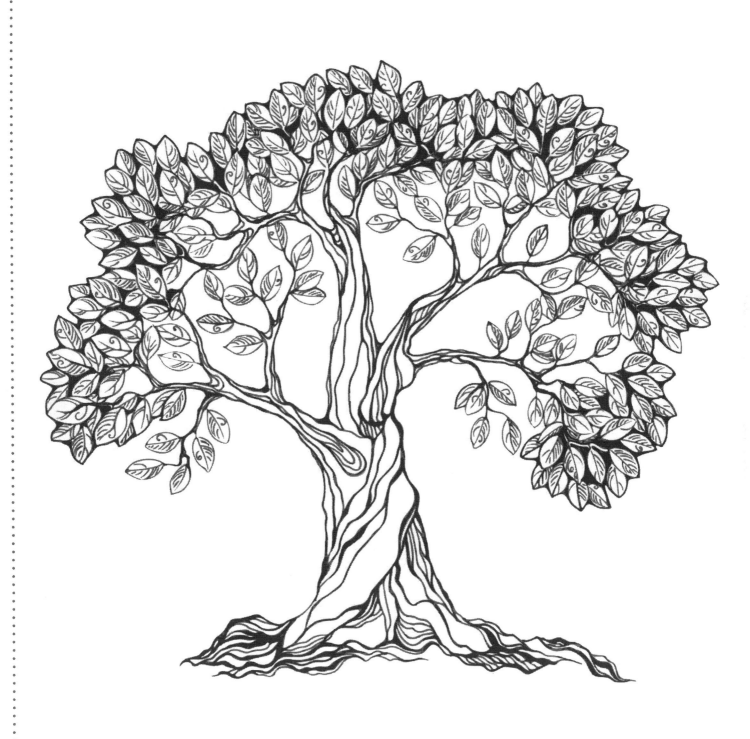

You do not really understand something unless you can explain it to your grandmother.

Proverb

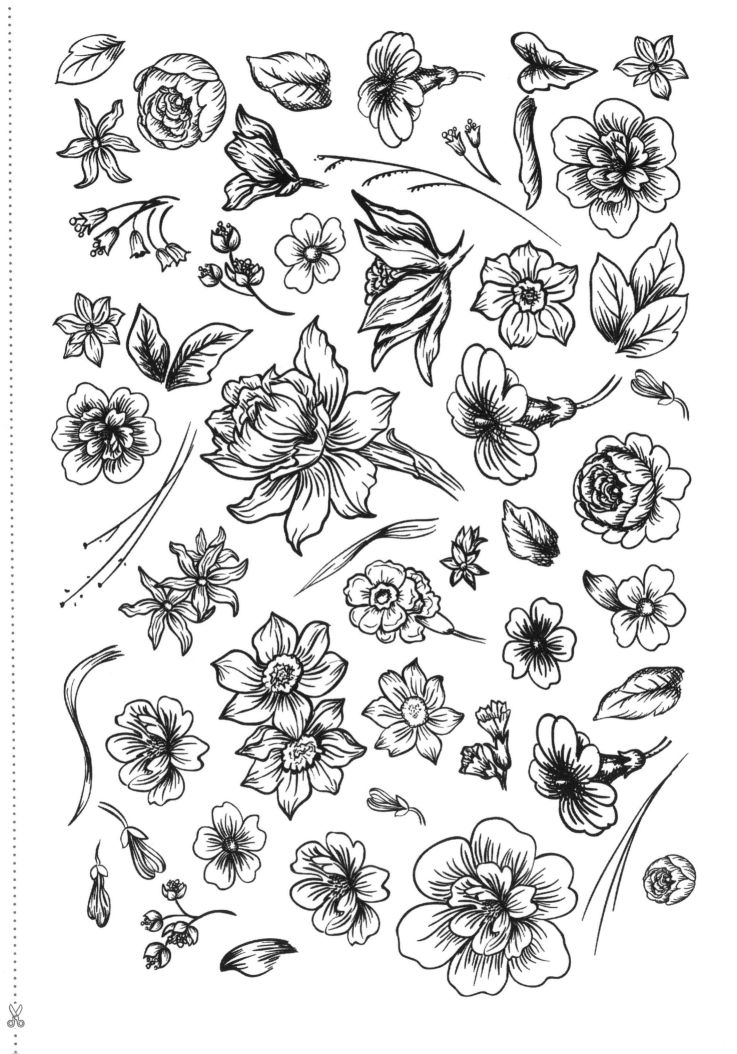

Young people need something stable to hang on to — a culture connection, a sense of their own past, a hope for their own future. Most of all, they need what grandparents can give them.

Jay Kesler

Also created by Christina Rose

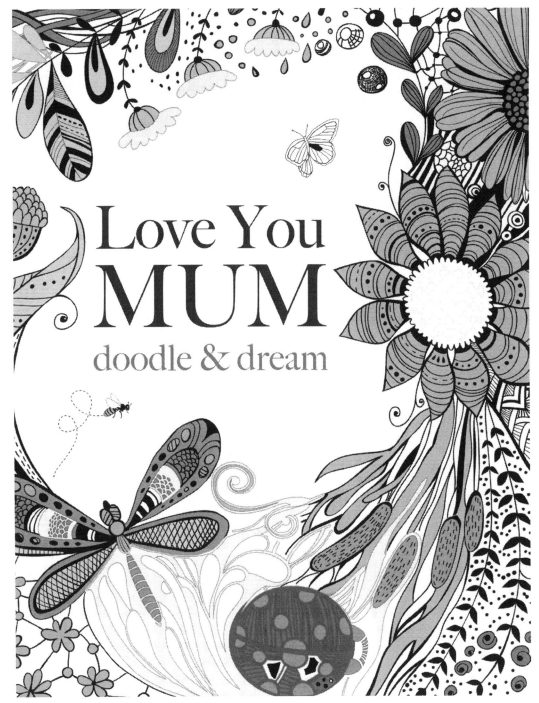

Love You
MUM
doodle & dream

A beautiful and inspiring adult colouring book for mums everywhere.

Give your mum the gift of relaxation with this inspiring colouring book.

Beautifully detailed black & white illustrations will take your mum on a journey of de-stressing art therapy, while the gorgeous words & quotes celebrating motherhood will remind her just how special she is.

Whether she already enjoys colouring or hasn't picked up a pencil for years she will find something here to love.

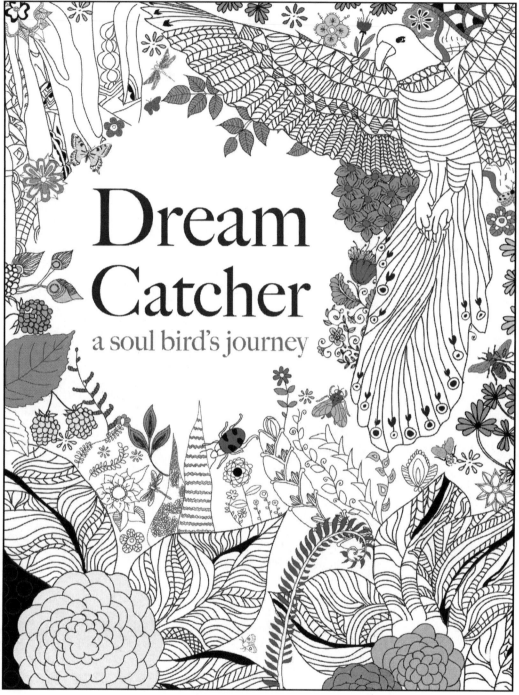

Dream Catcher
a soul bird's journey

A beautiful and inspiring colouring book for all ages

Take a journey of discovery with the soul bird as it travels through a black and white world of intricate scenes and dreams.

Appealing to all ages this gorgeous & inspiring colouring book reaches deeper and further than ever before. Beautifully detailed illustrations and motivational words encourage us to listen to the voice within ourselves and take your colouring journey into a new and thoughtful dimension.